Ms. Muffintop's

FANCY
Ball
Python

Adult Coloring Book

For Sheena and Zach.
With all my love.

Thank You Dear Customer!!!

For purchasing my book! What an amazing feeling.

Thank you for joining me on my artistic journey,

and for letting me share my love of ball pythons

with you. The best is yet to come!!!

Love XOXOs Ms. Muffintop

This book is made for coloring!

The pages can take heavy coloring, BUT put a

safety sheet behind the page you are coloring.

2 Copies of Each Coloring Page!

Single Page Use!

Color Test Pages!

Ms. Muffintop's

Color Test Page

Test your colors here!!!

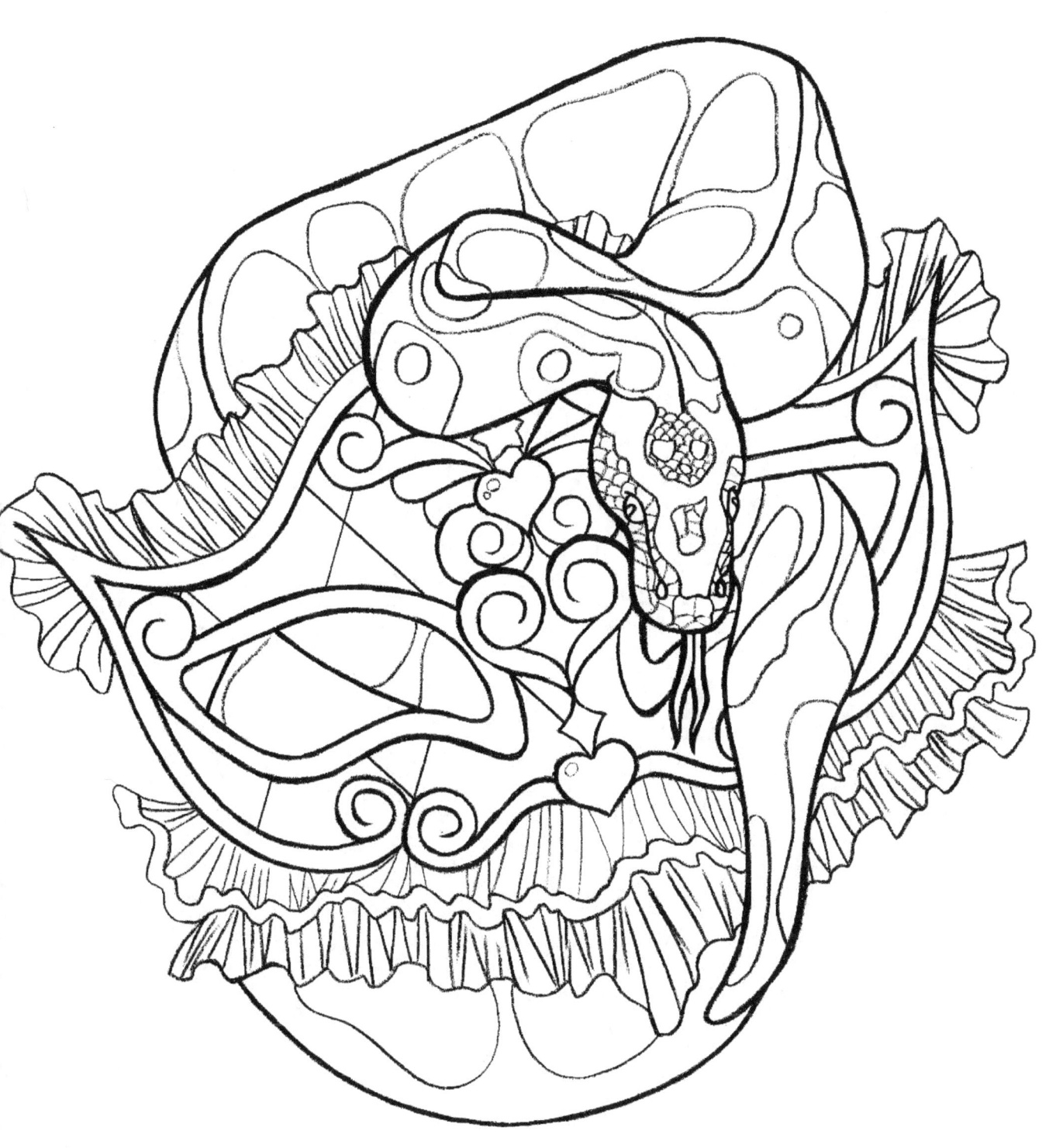

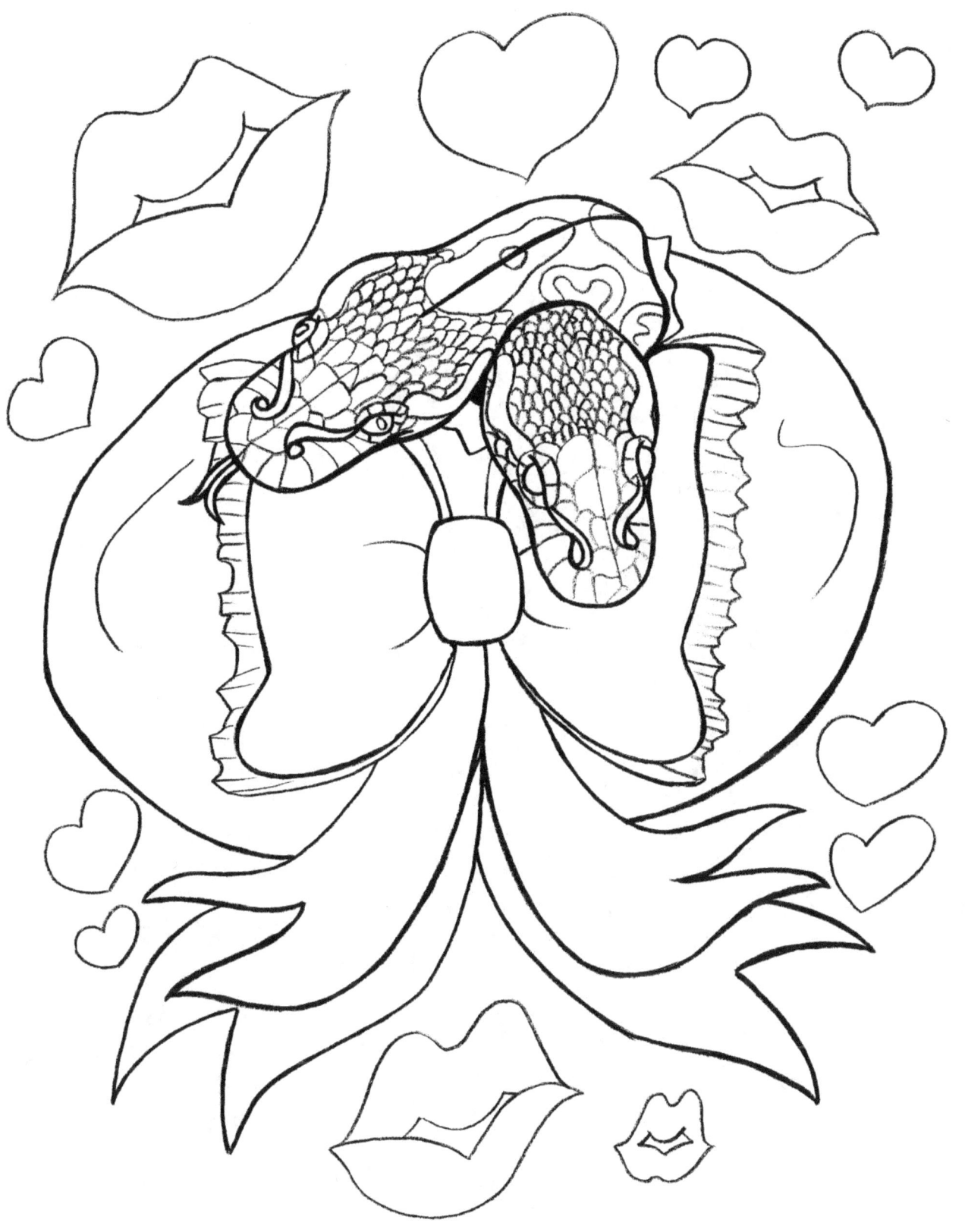

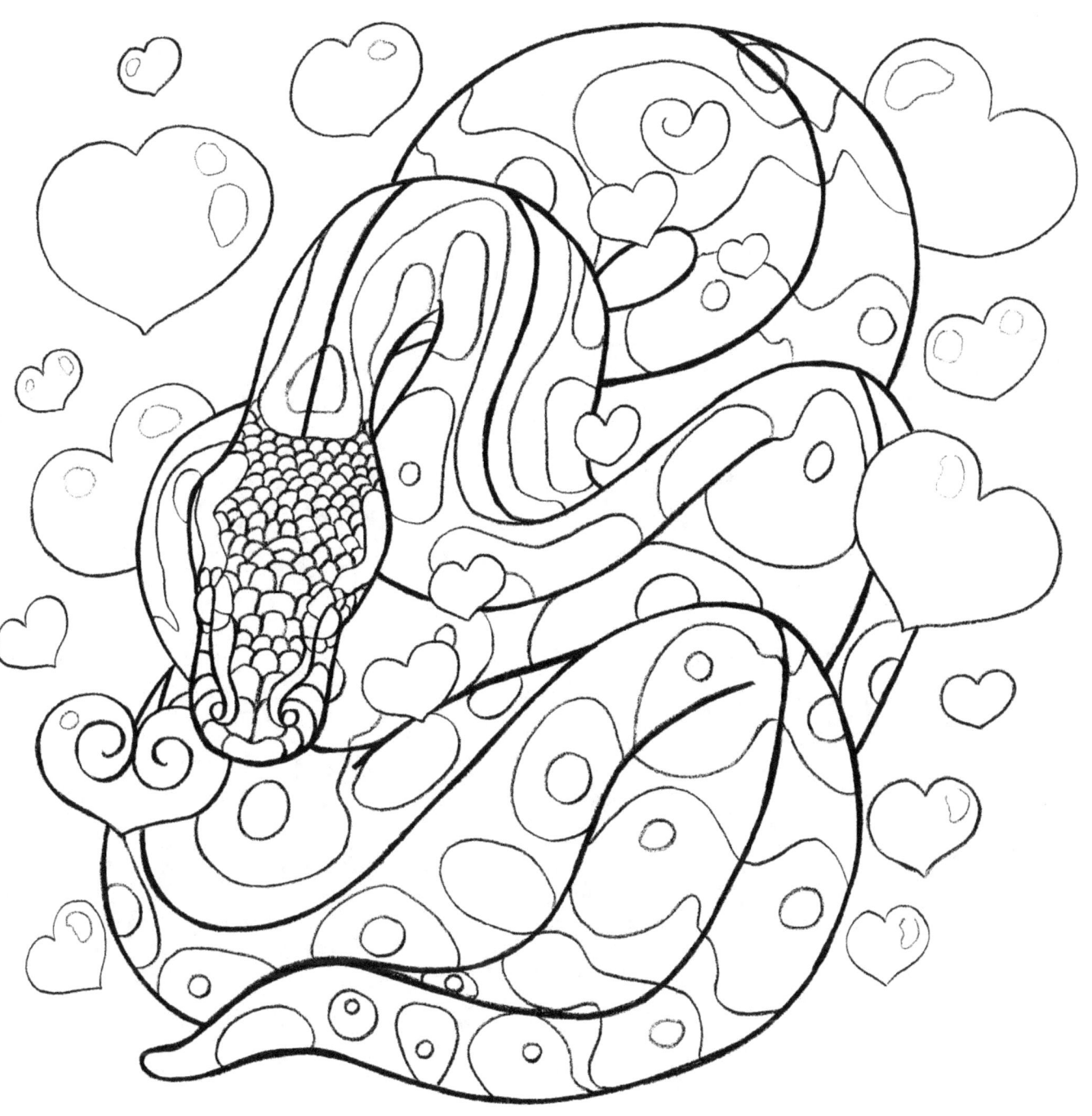

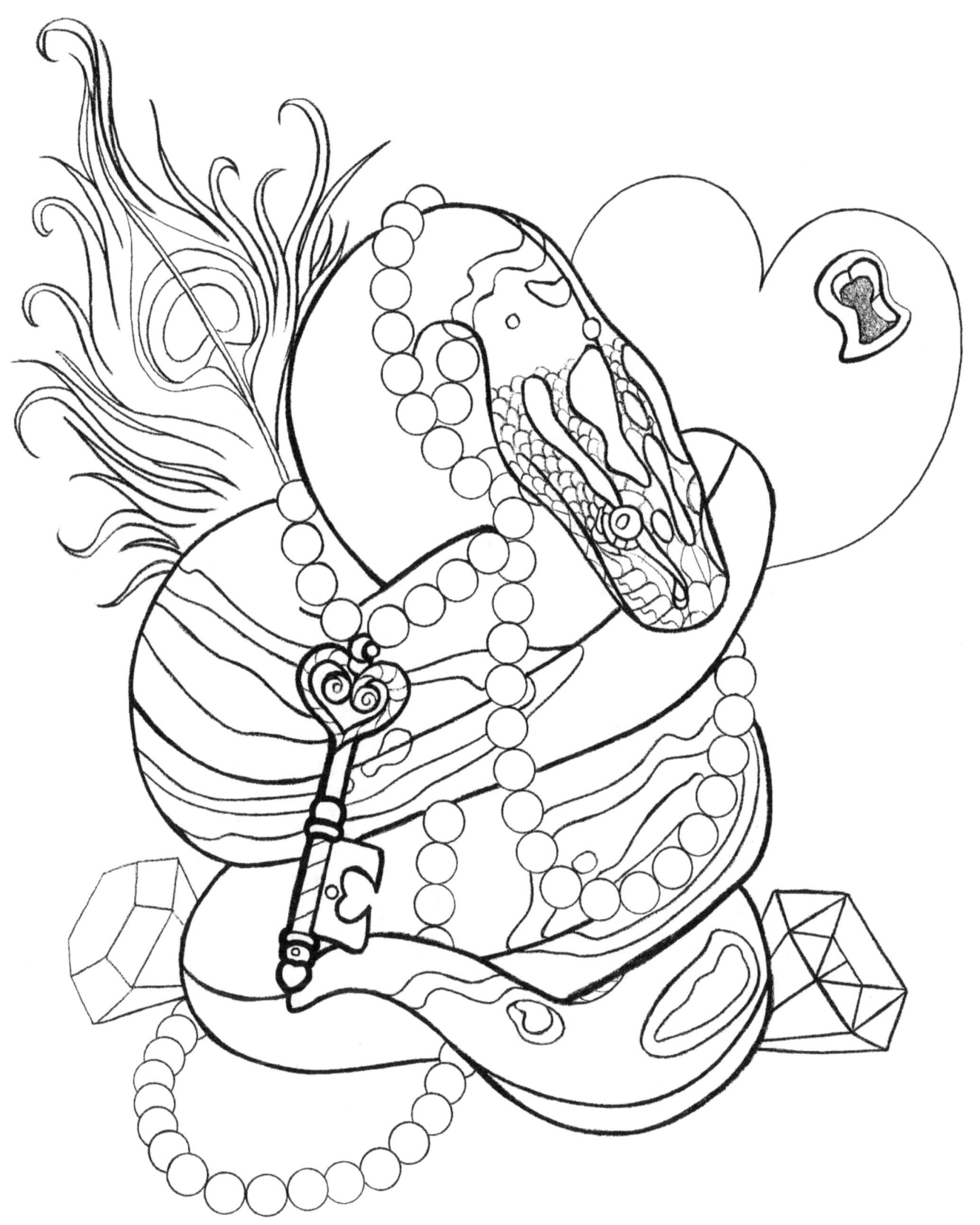

Ms. Muffintop's

Color Test Page

Test your colors here!!!

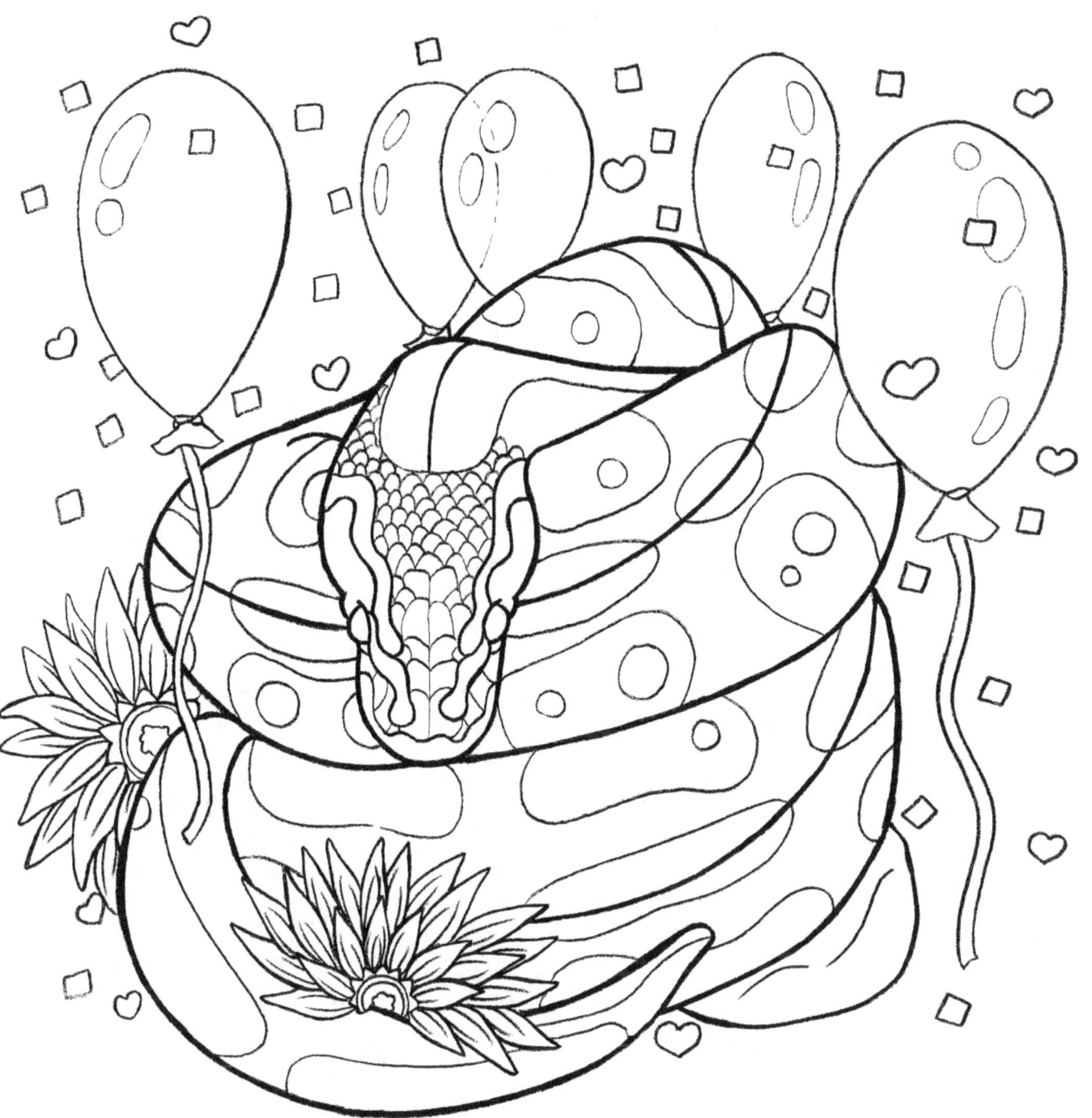

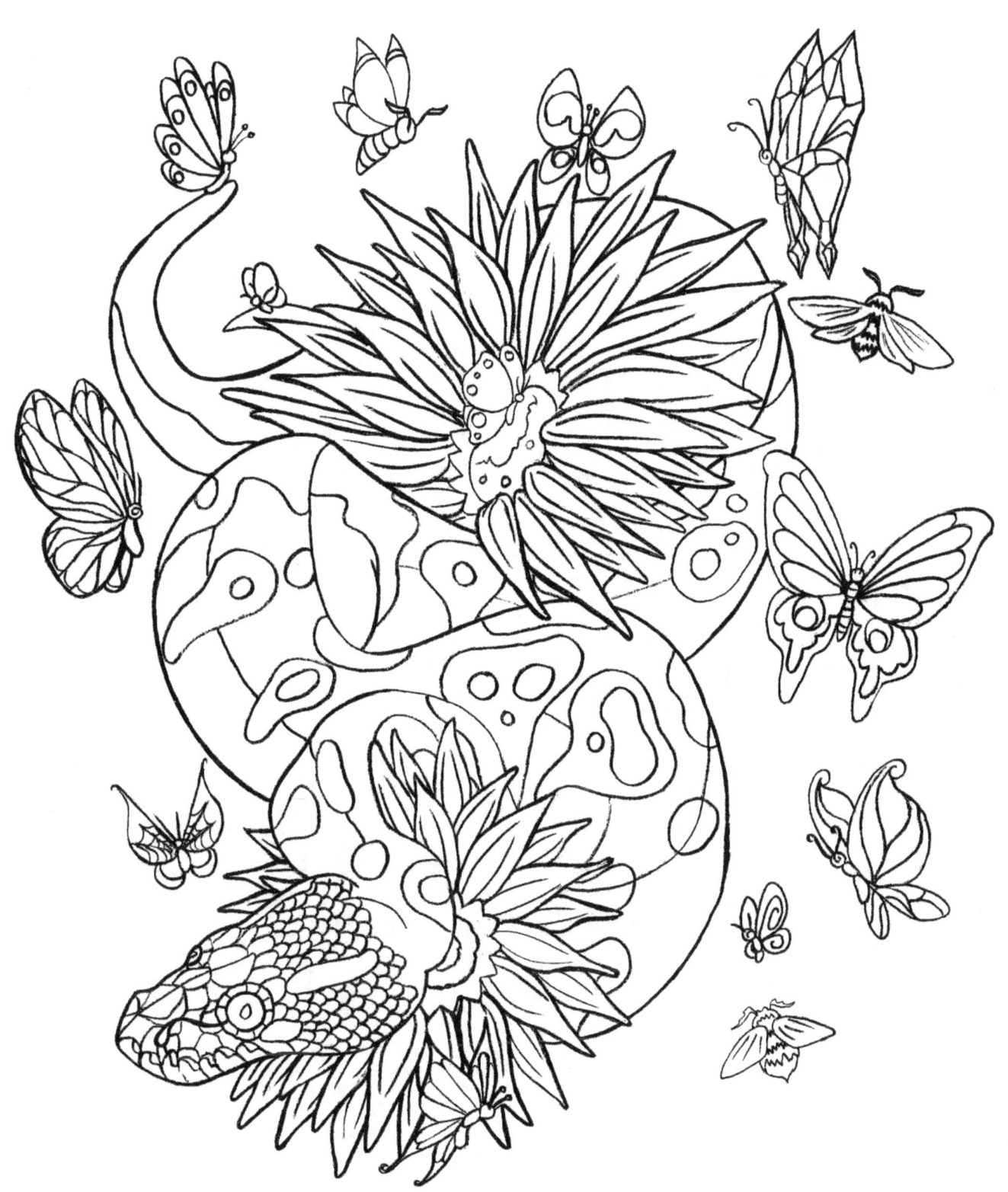

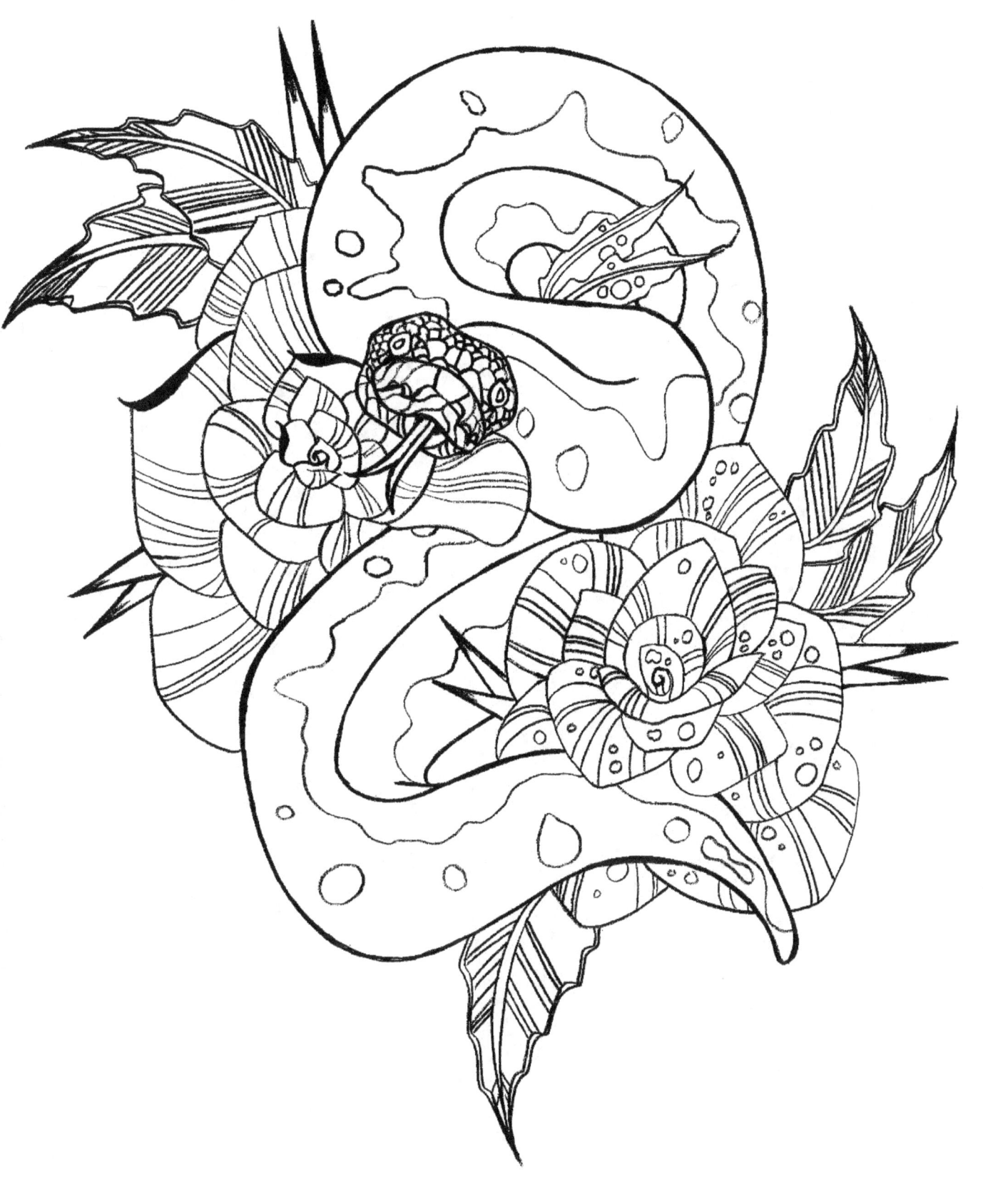

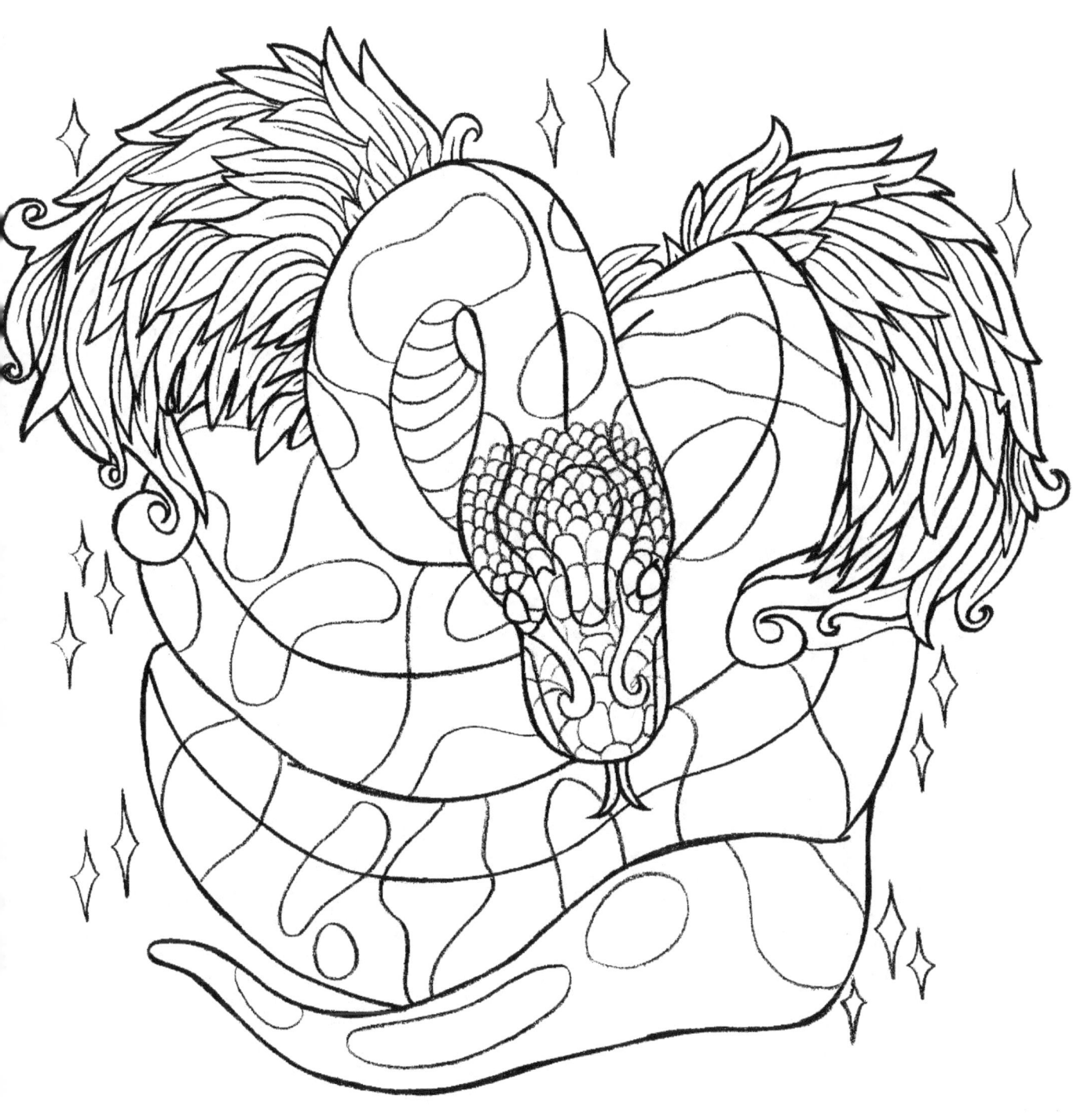

Ms. Muffintop's

Color Test Page

Test your colors here!!!

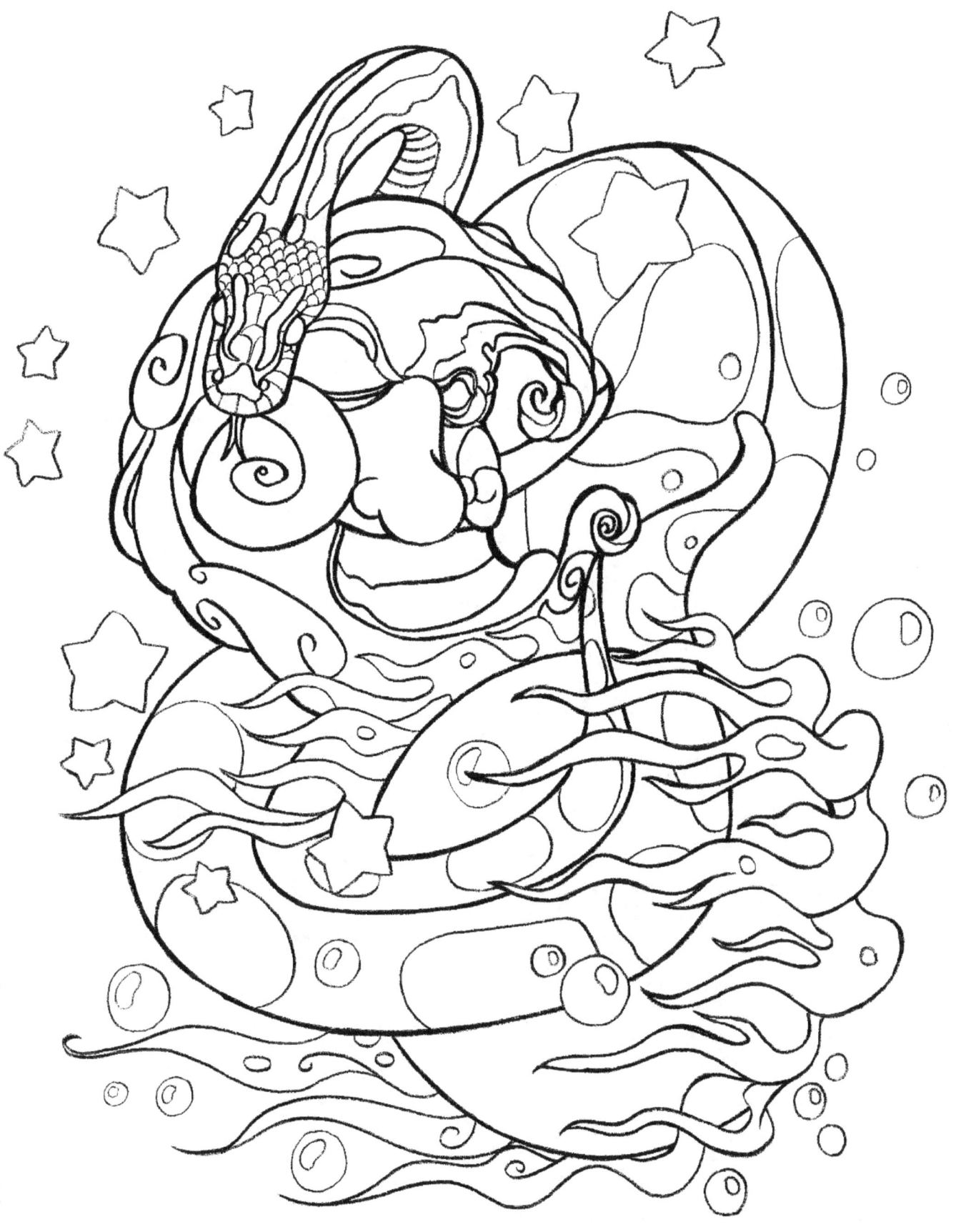

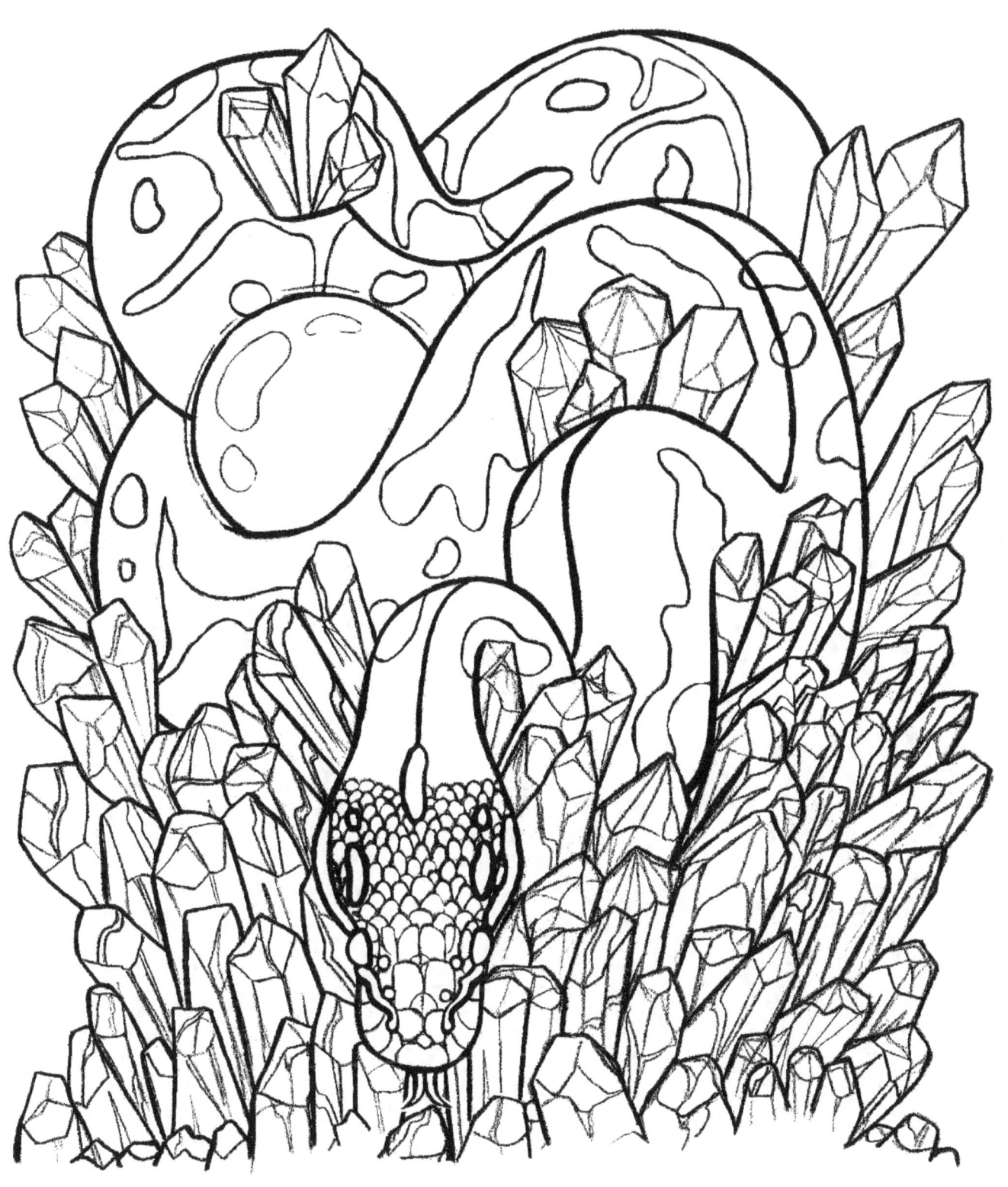

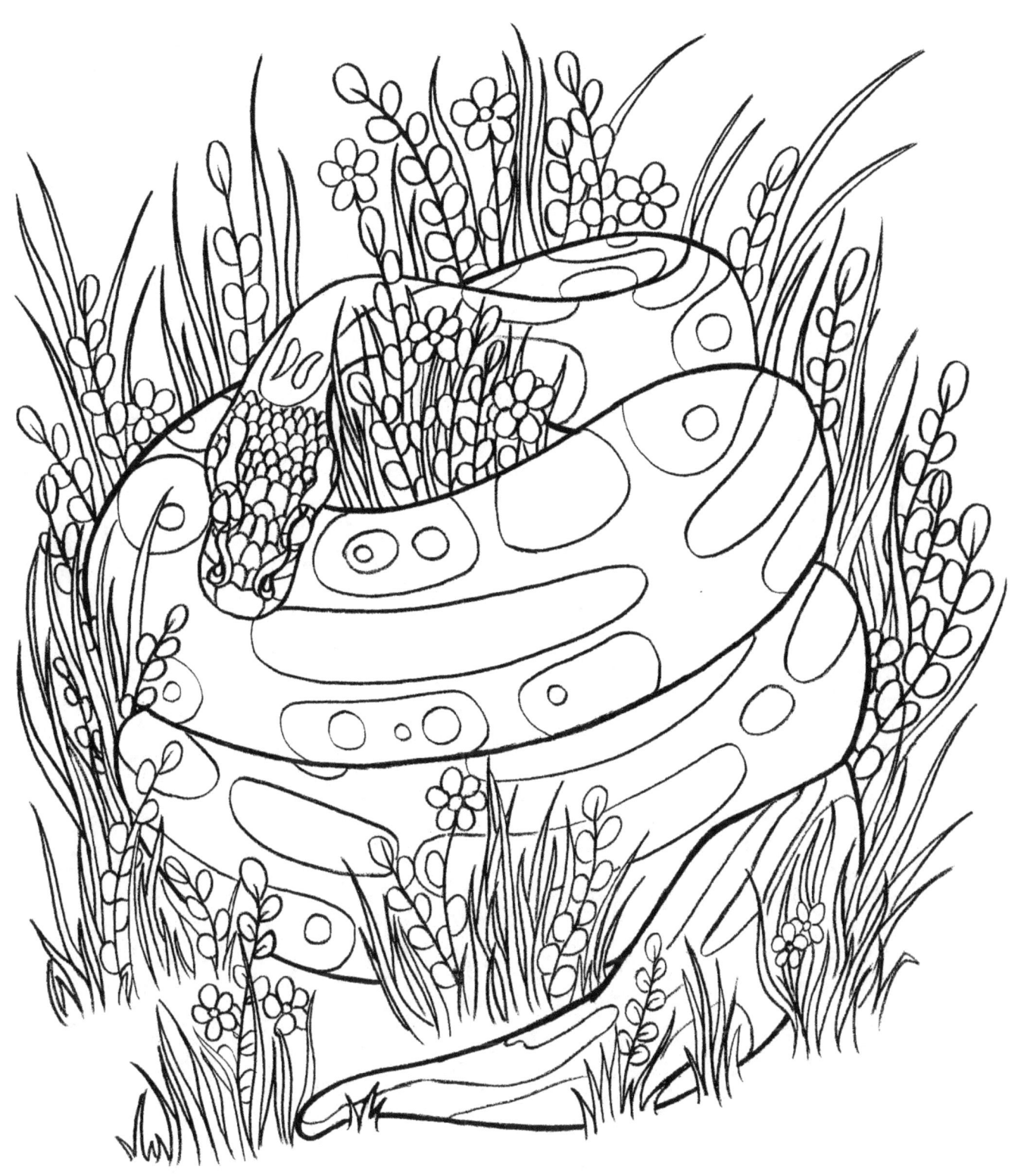

Ms. Muffintop's

Color Test Page

Test your colors here!!!

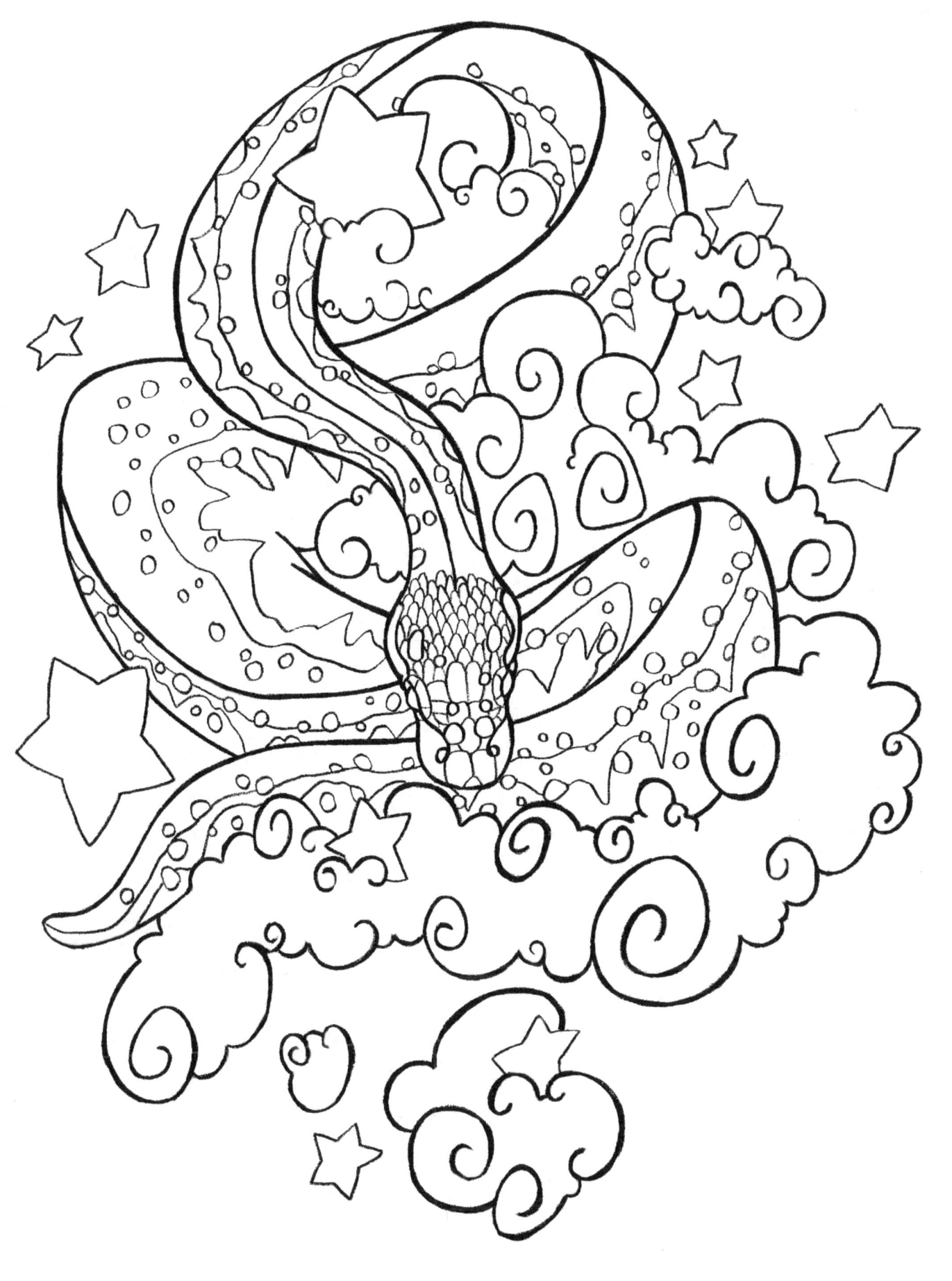

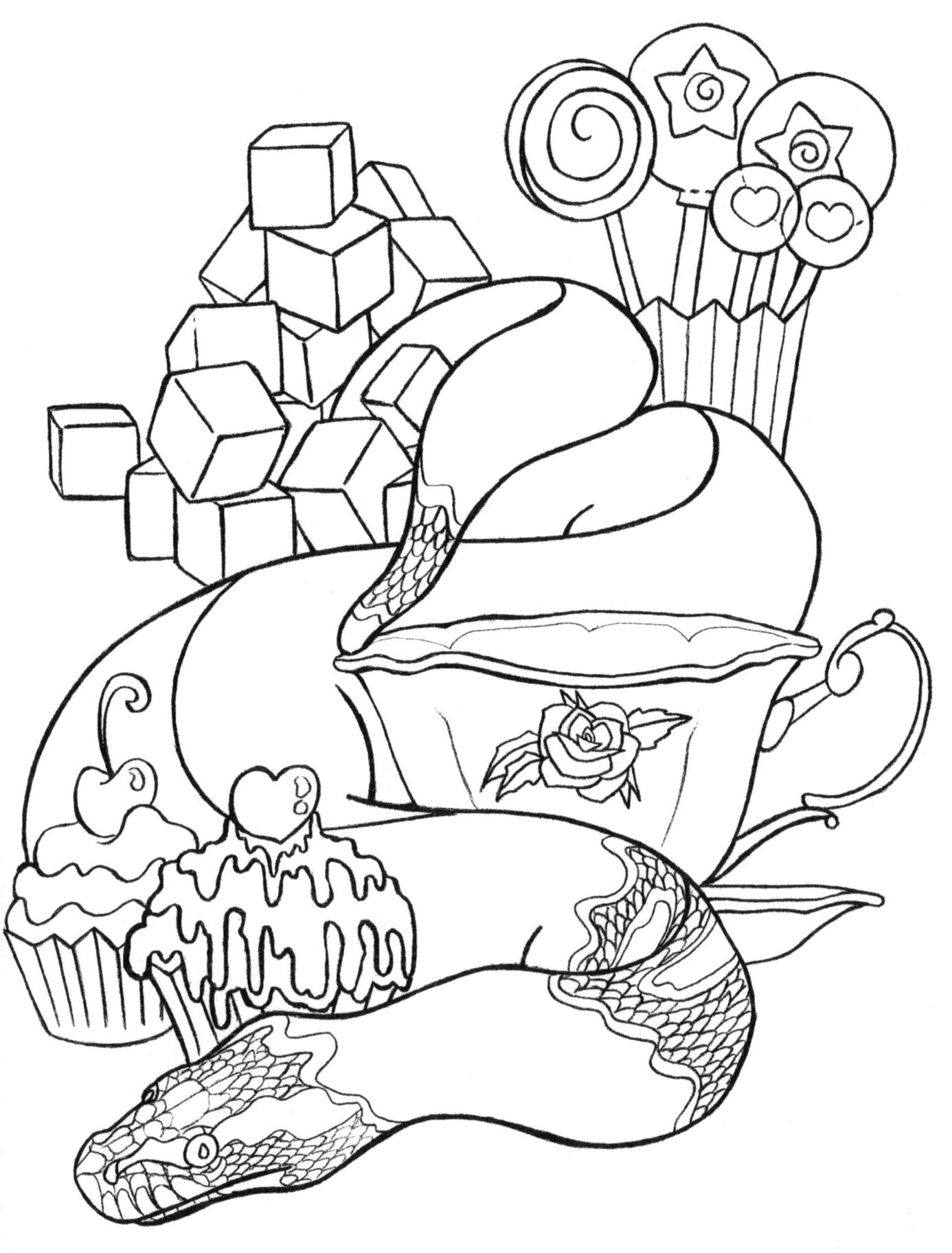

Ms. Muffintop's

Color Test Page

Test your colors here!!!

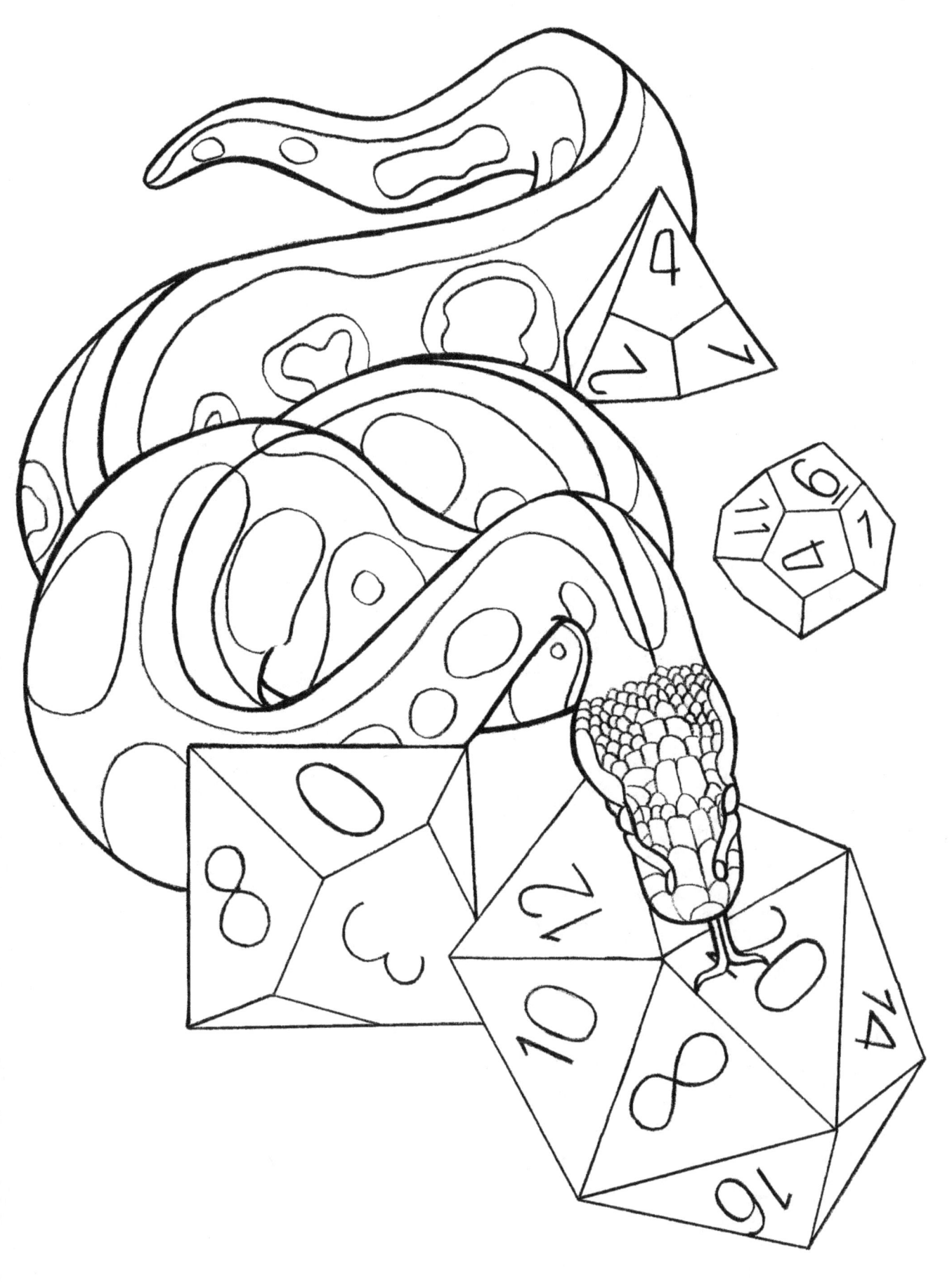

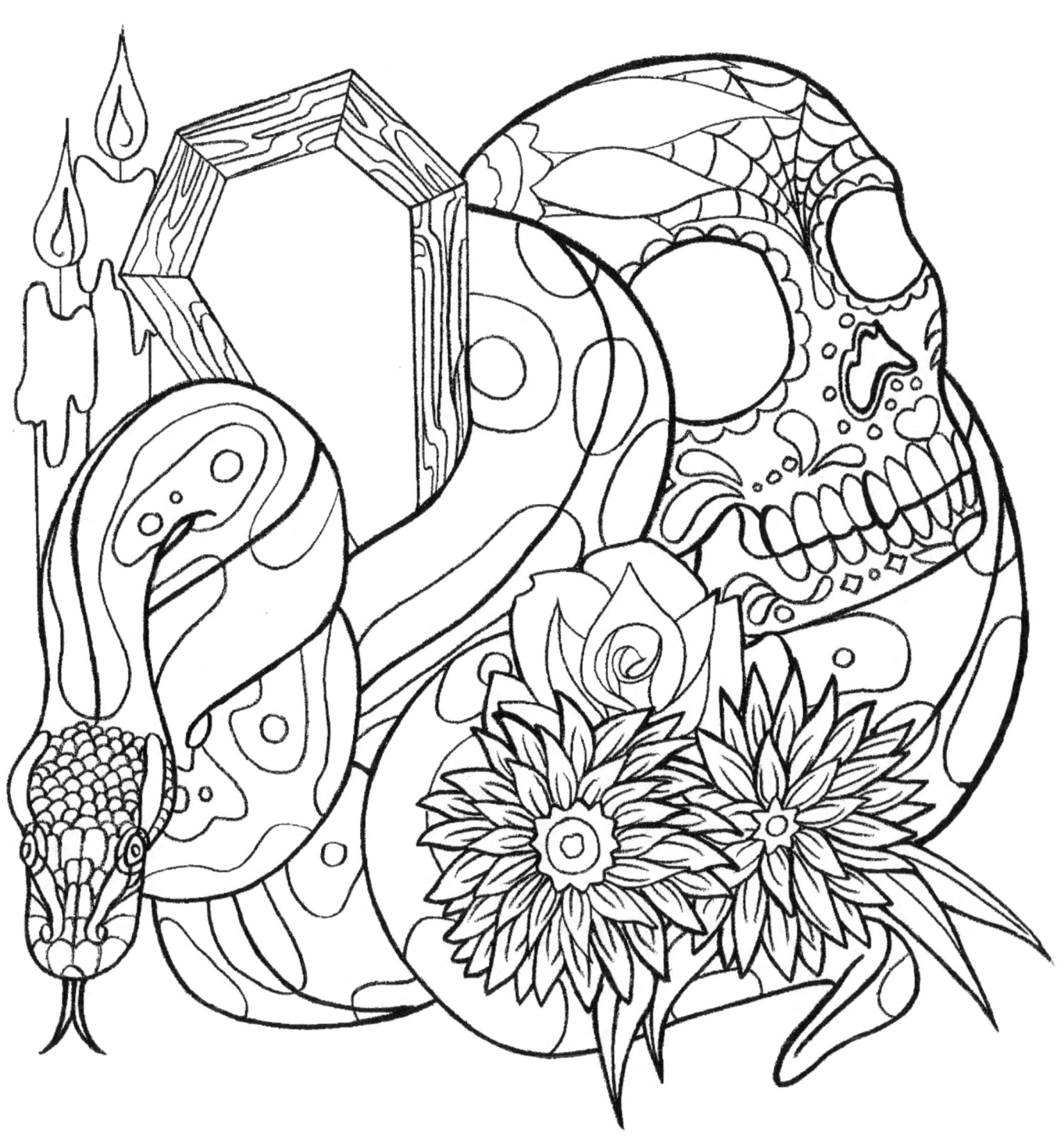

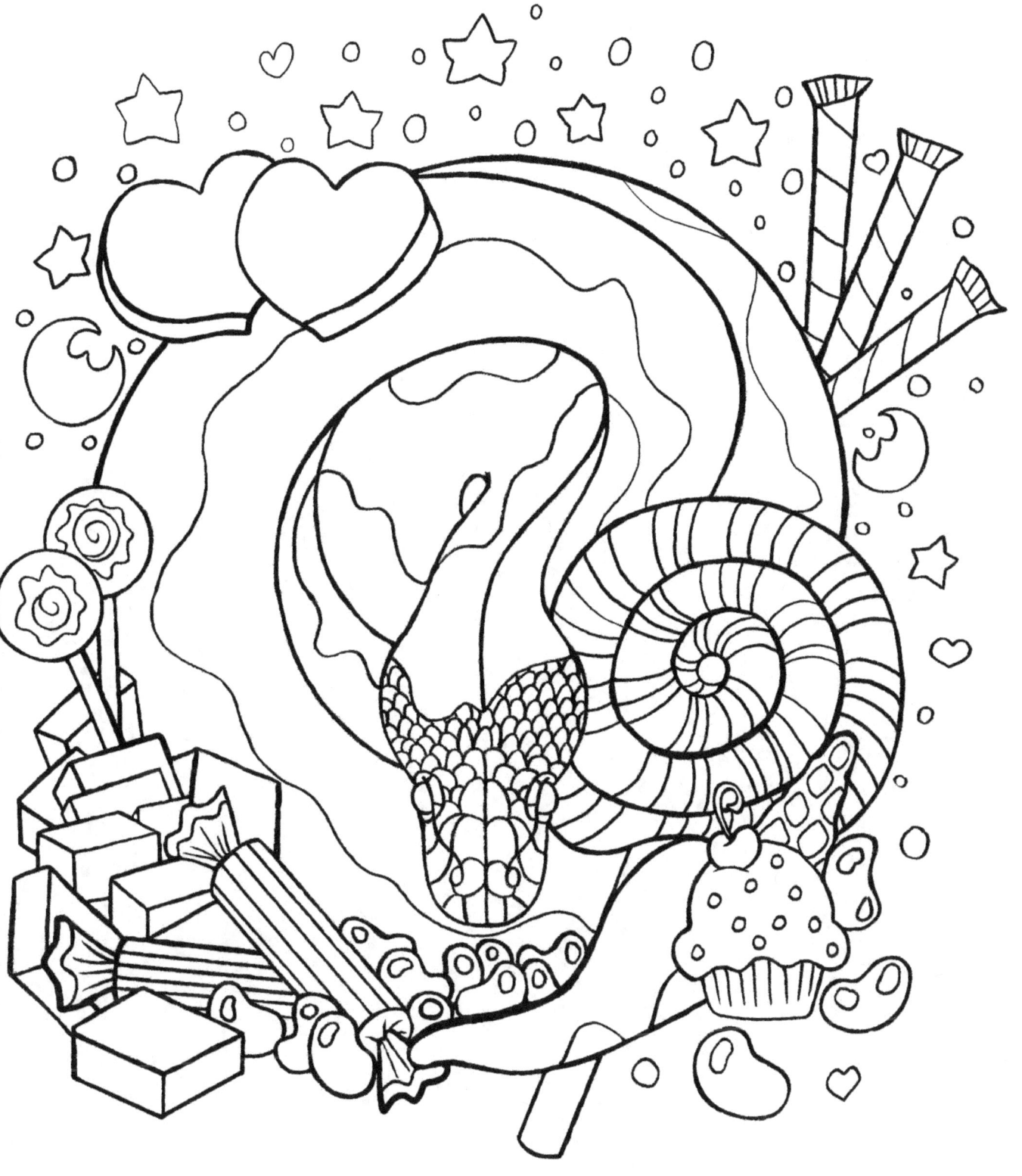

Ms. Muffintop's

Color Test Page

Test your colors here!!!

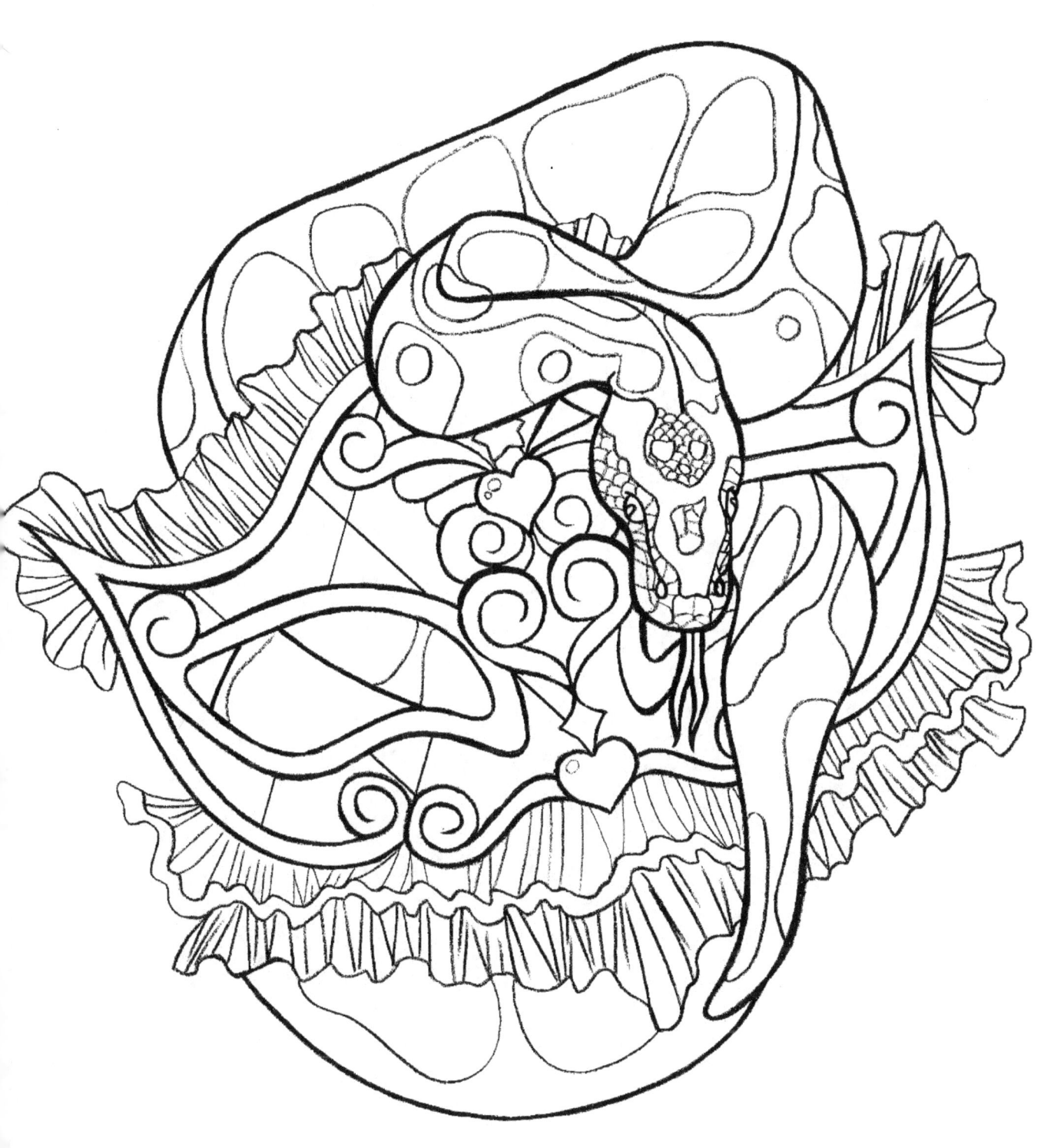

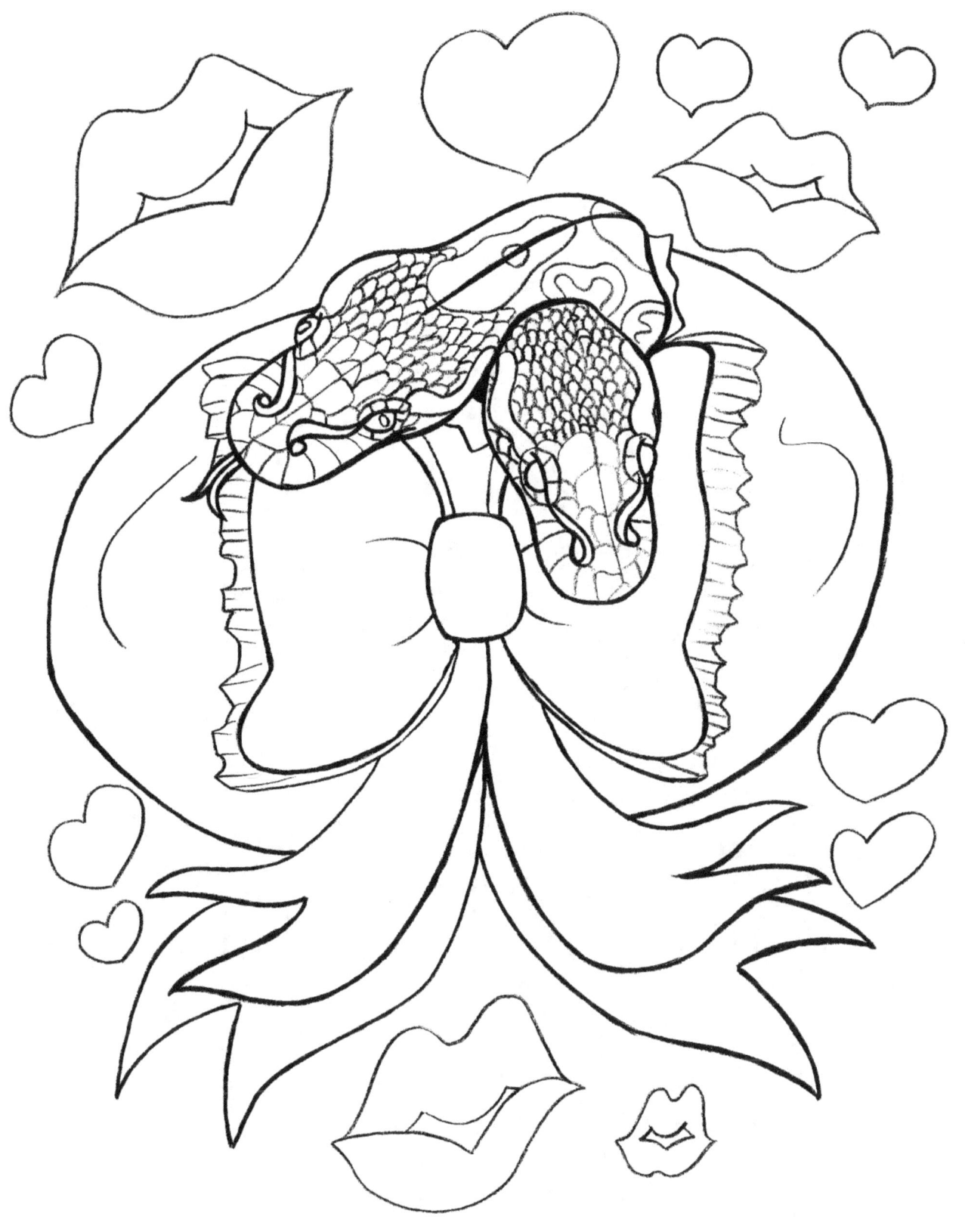

Ms. Muffintop's

Color Test Page

Test your colors here!!!

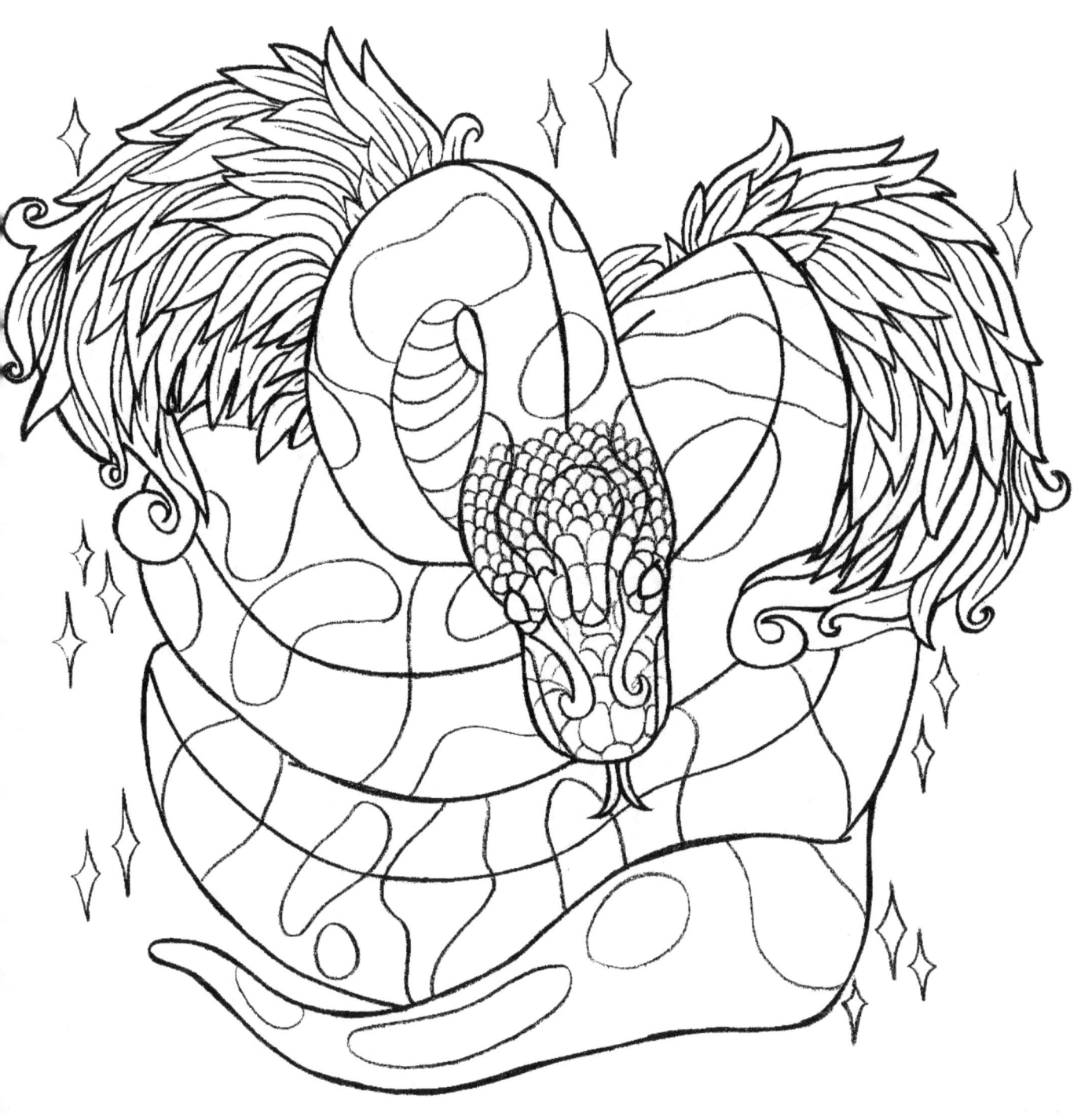

Ms. Muffintop's

Color Test Page

Test your colors here!!!

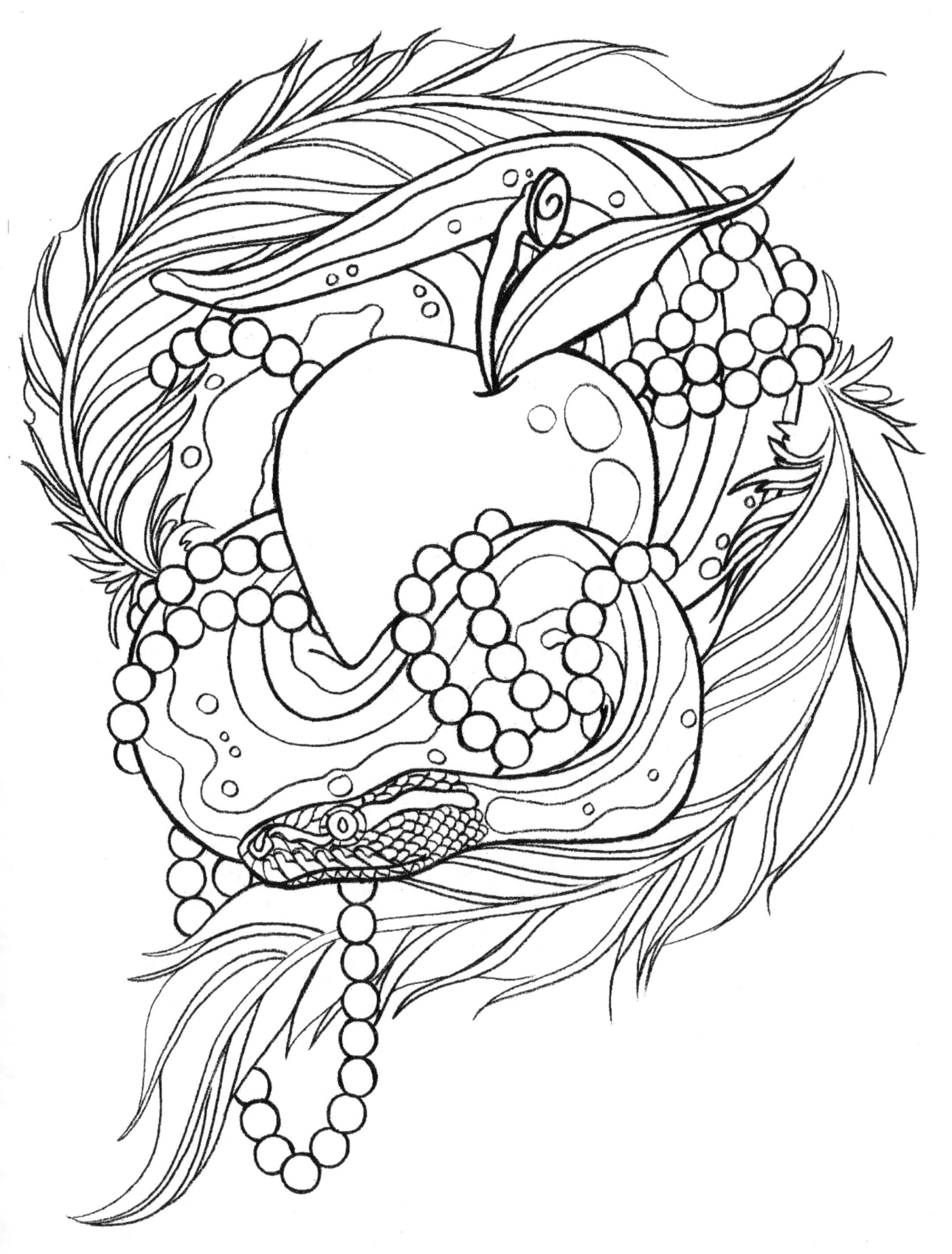

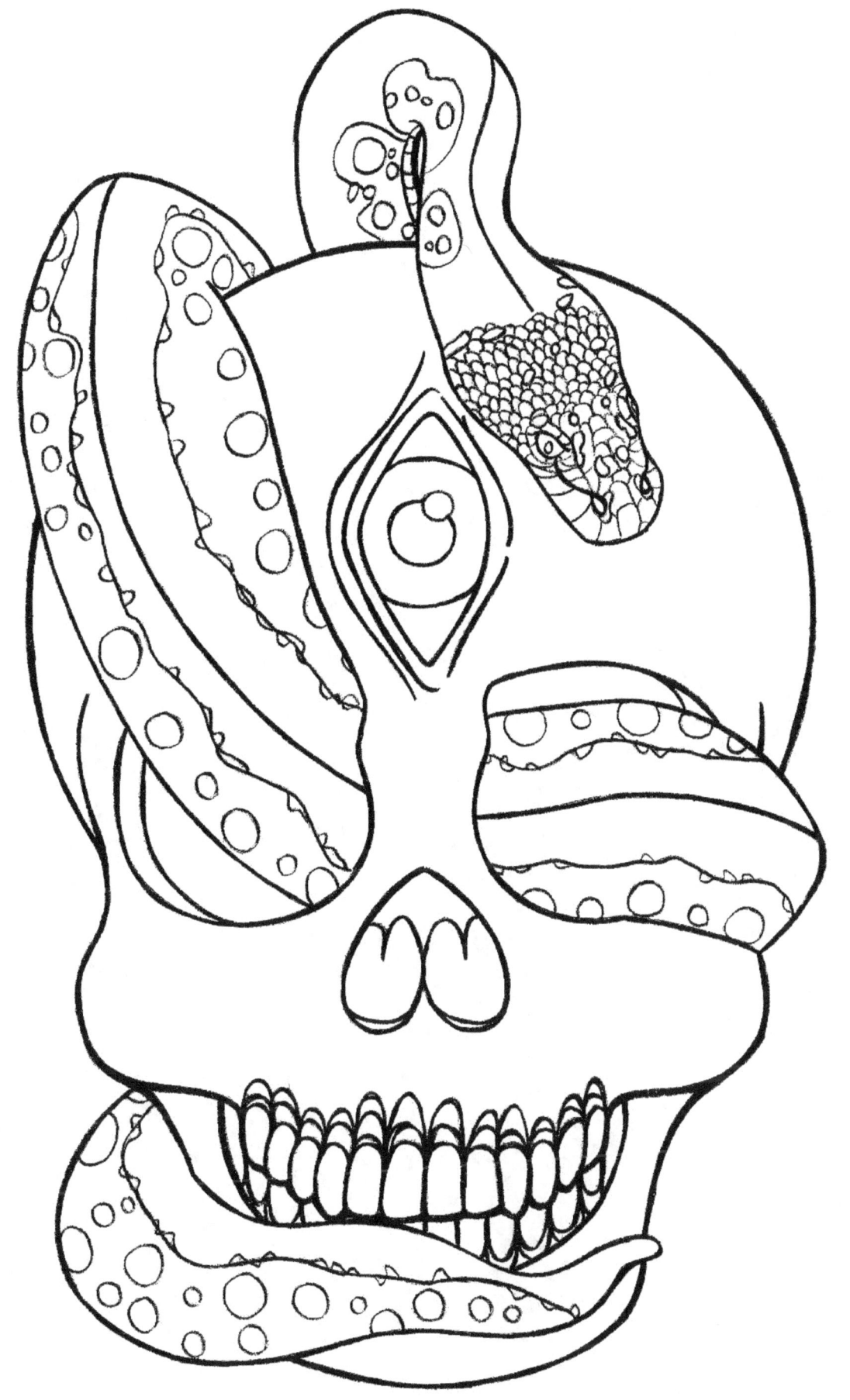

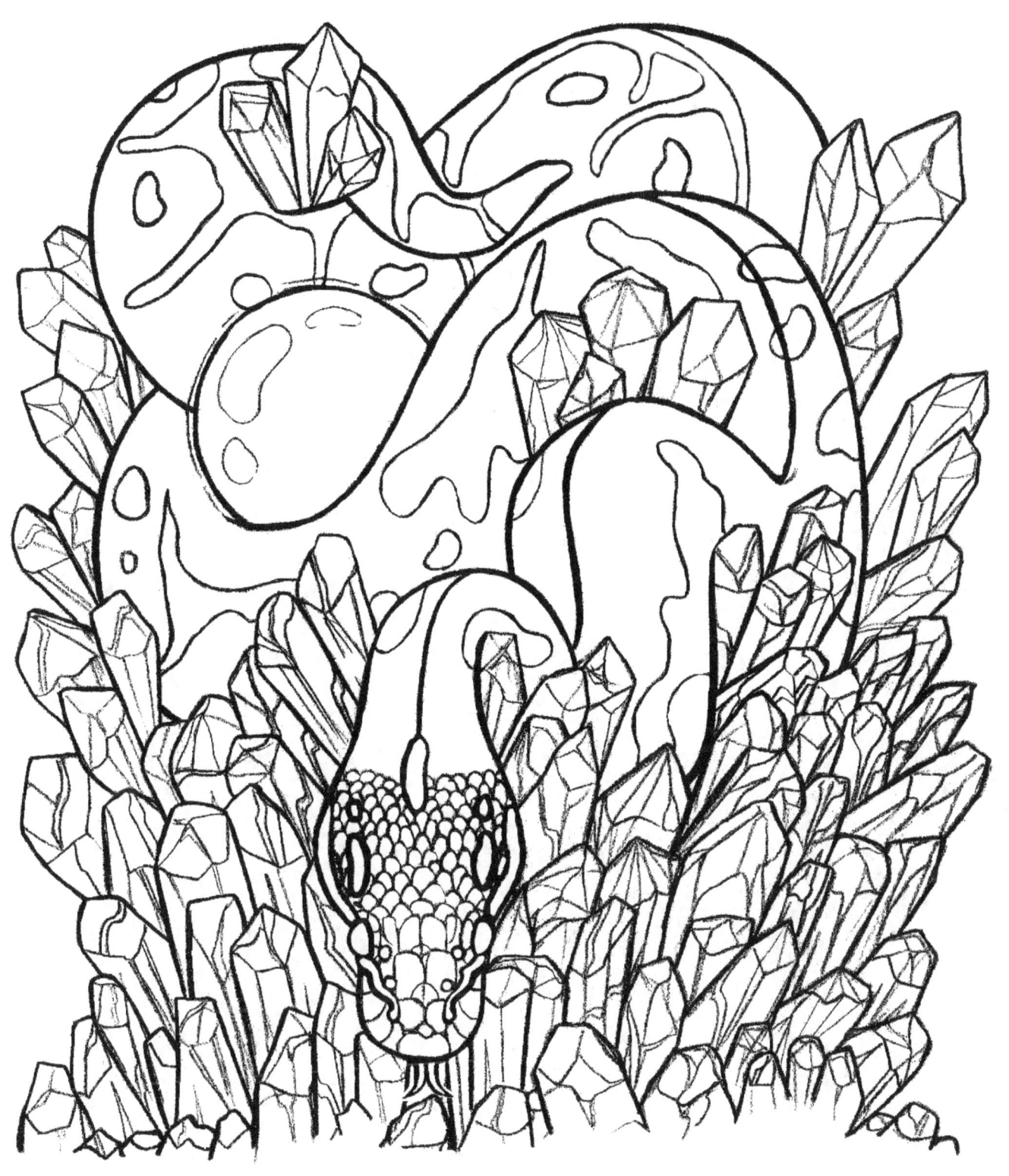

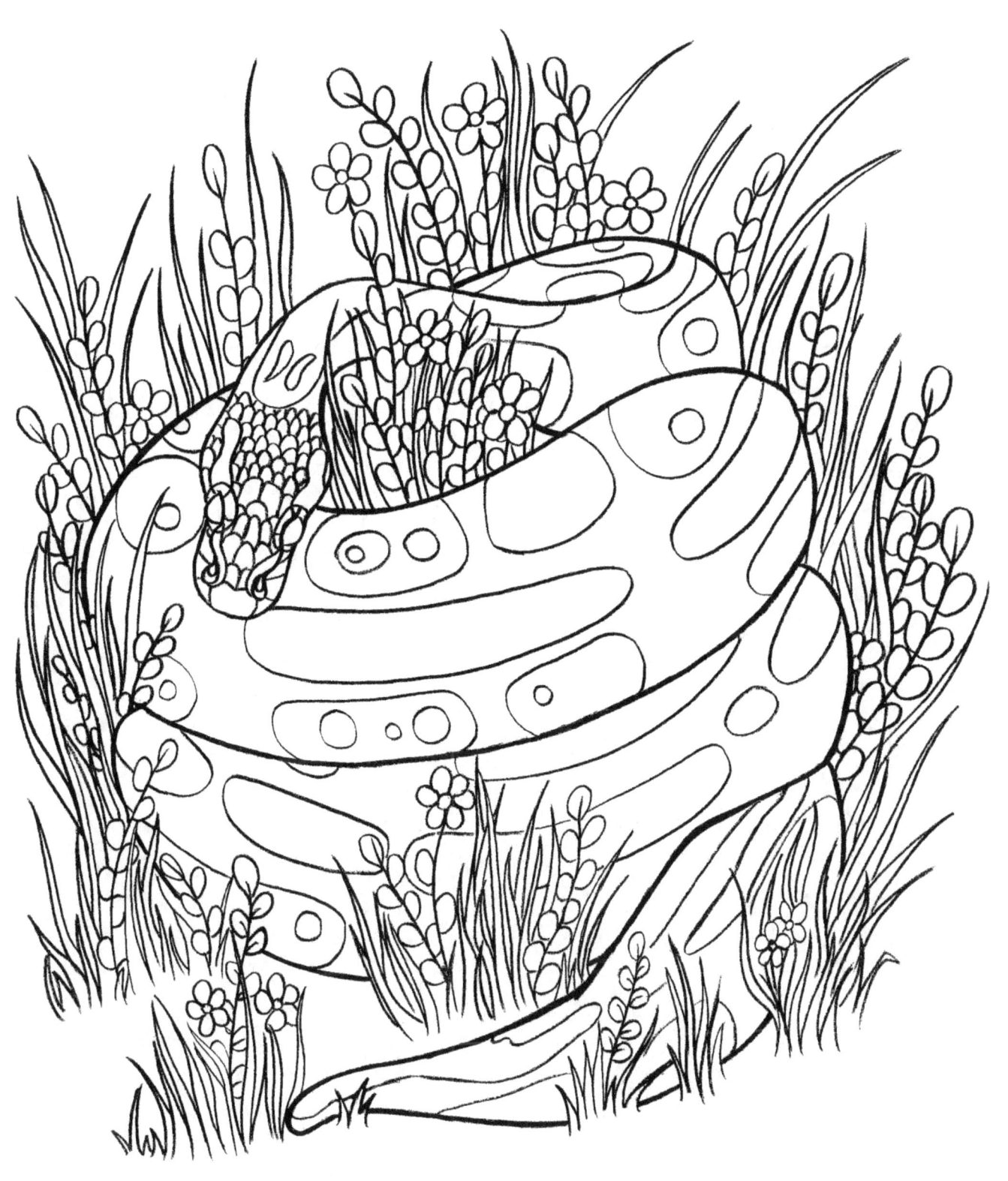

Ms. Muffintop's

Color Test Page

Test your colors here!!!

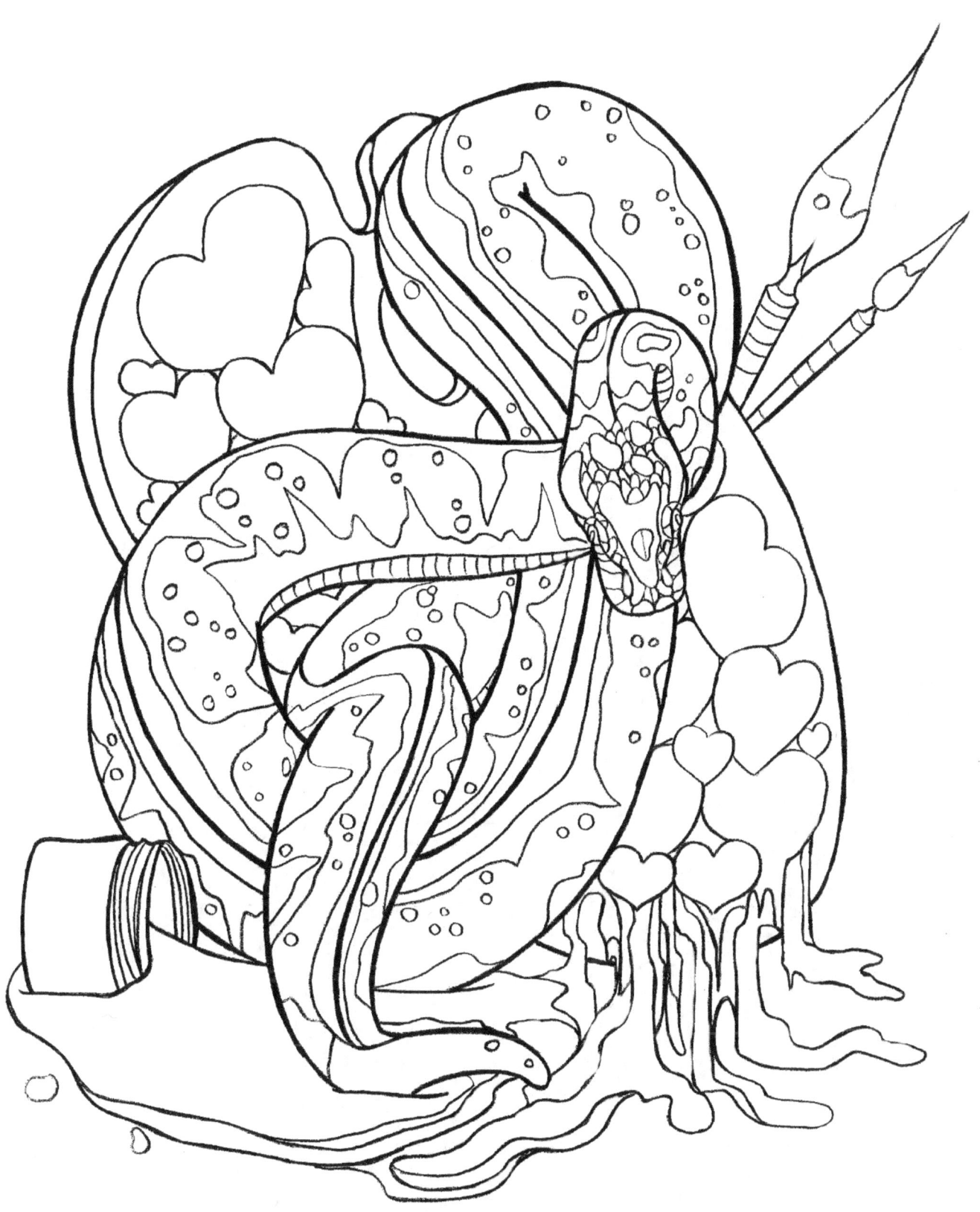

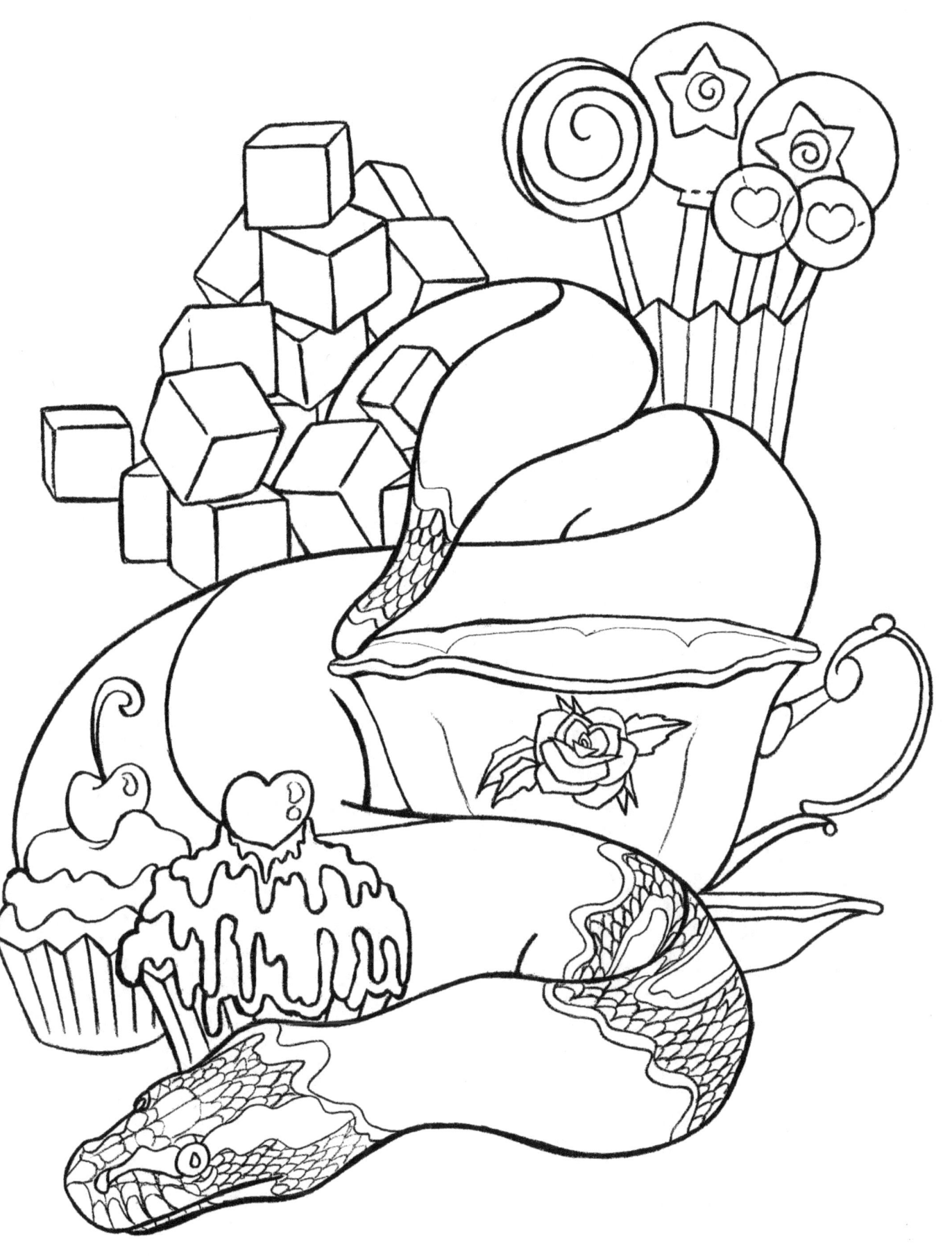

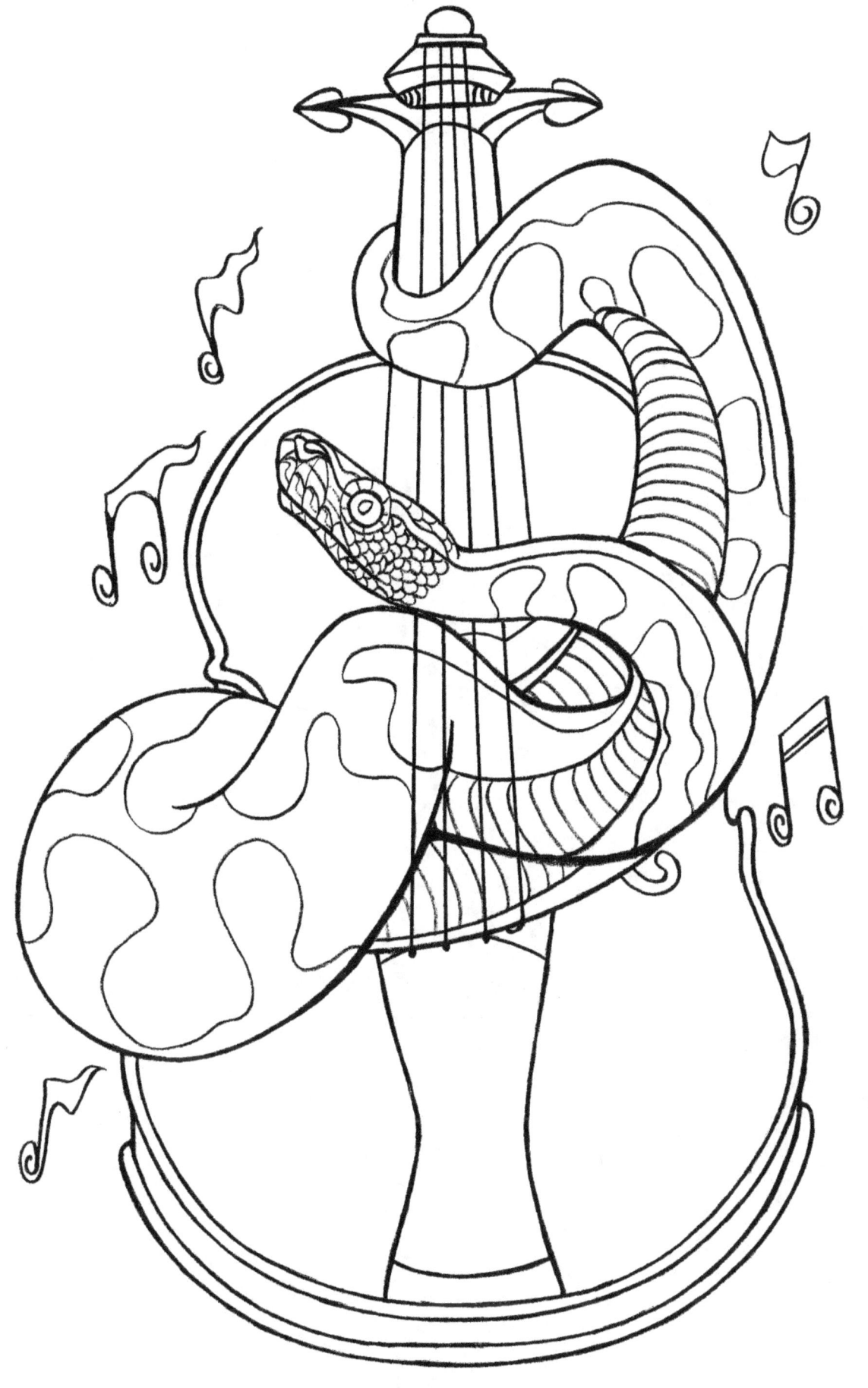

Ms. Muffintop's

Color Test Page

Test your colors here!!!

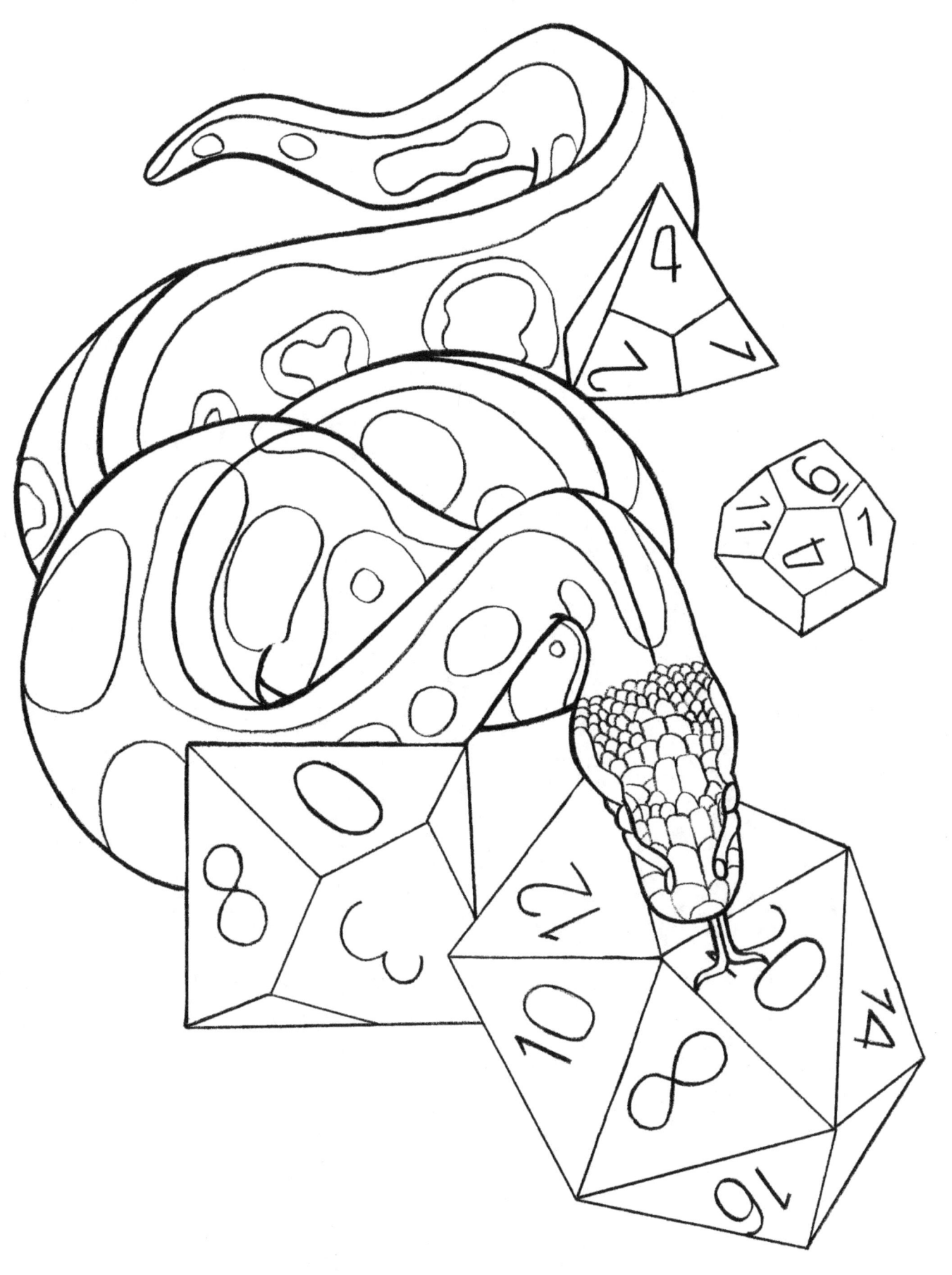

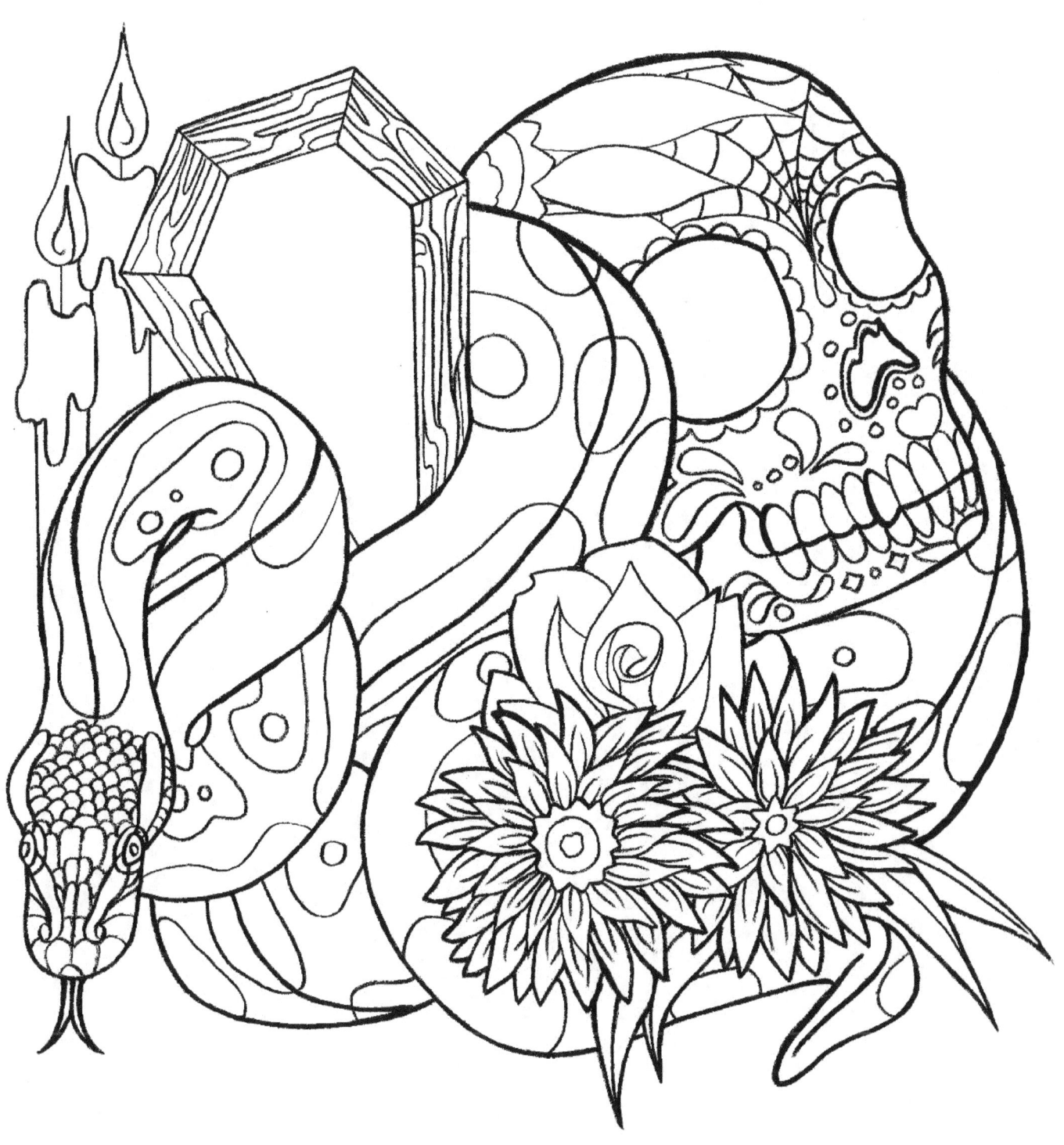

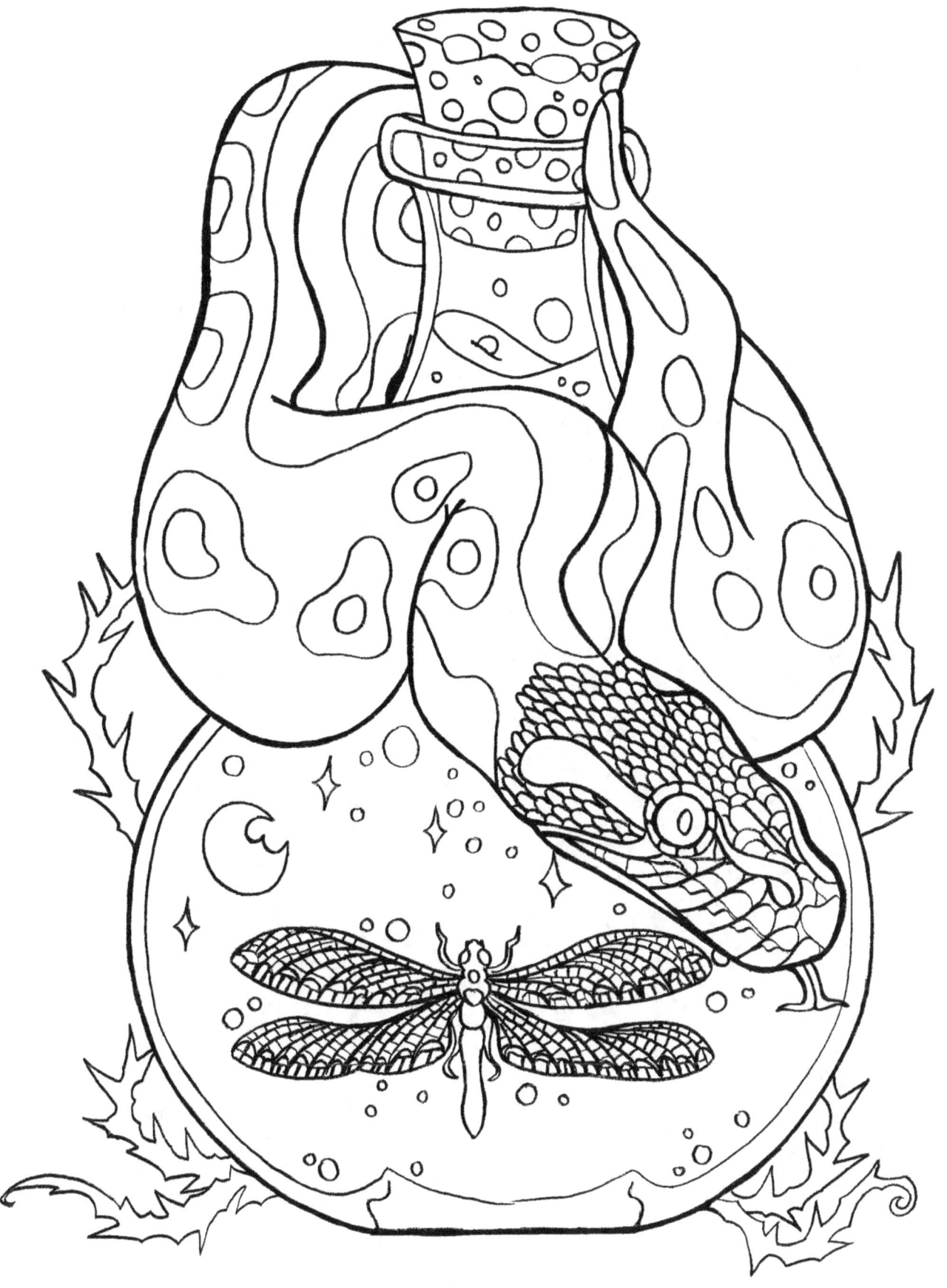